T0018450

Pharrell-isms

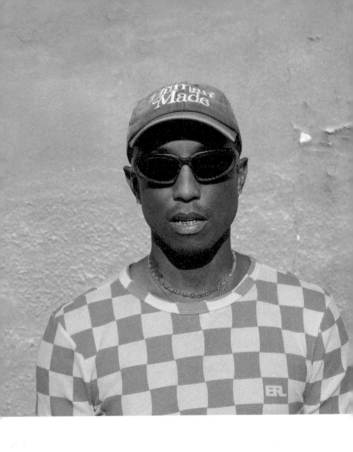

Pharrell-isms

Pharrell Williams

Edited by Larry Warsh

PRINCETON UNIVERSITY PRESS
Princeton and Oxford

in association with
No More Rulers

Published by Princeton University Press,
41 William Street, Princeton, New Jersey 08540
In the United Kingdom: Princeton University Press,
99 Banbury Road, Oxford OX2 6JX
press.princeton.edu
in association with
No More Rulers
nomorerulers.com
ISMS® is a registered trademark of No More Rulers, Inc.
NO MORE RULERS® is a registered trademark.

ℙ PRINCETON ~~NO MORE RULERS~~ ®

All Rights Reserved

ISBN 9780691244990
Library of Congress Control Number: 2022945592
British Library Cataloging-in-Publication Data is available

This book has been composed in Joanna MT
Printed on acid-free paper. ∞
Printed in China
1 3 5 7 9 10 8 6 4 2

CONTENTS

INTRODUCTION

Pharrell Williams personifies talent. He is an individual who bends and transcends the many fields in which he creates. Pivoting among music, art, fashion, and design, he combines them in ways that are innovative and deeply conceptual. Remarkably prolific, generating projects at an astounding rate, Pharrell is mindful and deliberate in his thinking and his actions. He has described himself as a "spiritual unit of awareness," and that approach—that sense of being part of a larger whole—is reflected in all he does.[1]

Pharrell Williams is also a philanthropist who cares deeply about future generations. He is an outspoken advocate for social justice and the empowerment of women, for amplifying the voices of African Americans, and above all for the

importance of education in achieving a better world. "Education is the death blow to discrimination," he has said. "Equality is achieved via education."[2]

Pharrell was born in 1973 in Virginia Beach, Virginia. As a child, "I was like a nerdy little Black kid on a skateboard," as he put it.[3] He found his "inner sanctum" in music: at his parents' churches, in his own experiences at band camp, and in pop-music favorites like Earth, Wind, and Fire, Stevie Wonder, and Steely Dan.[4] Early in his career he worked with producer Teddy Riley on the 1992 Wreckx-N-Effect hit single "Rump Shaker." A few years later, he produced N.O.R.E.'s single "Superthug" with his childhood friend and longtime collaborator Chad Hugo. With Chad, Pharrell created the duo the Neptunes in 1992, followed by the band N.E.R.D in 1999. The success of those groups accelerated both

men's careers and foreshadowed countless future collaborations.

Pharrell's unparalleled skills in the recording studio, his genuinely cooperative spirit, and his embrace of creativity in the production process have resulted in a string of collaborations that have all but defined popular culture over the past decades. To date, that output has earned thirteen Grammys, two Oscar nominations, and four Billboard number one hits. A small sampling of the musical talent Pharrell has worked with includes Ludacris, Jay-Z, P. Diddy, Britney Spears, Beyoncé, Justin Timberlake, Gwen Stefani, Madonna, Daft Punk, Tyler the Creator, Ariana Grande, and Kendrick Lamar. His work with these and other artists has been a defining influence on contemporary pop music—along with his chart-topping solo records, including the 2014 Grammy-winning album Girl.

No music is more closely identified with Pharrell than his 2013 single "Happy," from the soundtrack album for Despicable Me 2. Irresistibly cheerful and inspiring, it is one of his enduring contributions to an uplifted global vibe.

That sense of uplift and unconventional thinking extends to his work in other areas. In his engagement with fashion, for instance, Pharrell has encouraged and embodied a rethinking of traditional masculinity, reflected in part in his unabashed embrace of fashion and luxury. It is also evident in the complex ways that, in matters of personal attire, he plays with color, form, and texture. Pharrell's knack for combining historical styles with his own looser, more improvisational take on menswear has encouraged new approaches to masculine self-presentation, on an individual level and within the industry. Along with his labels Billionaire Boys Club and

Icecream, his work in fashion has included collaborations with Chanel, Louis Vuitton, Tiffany & Co., and other iconic brands.

In all areas, Pharrell's work is marked by openness and collaborative spirit. He is a boundless optimist who embraces and holds space for difference. His creative and philanthropic projects reflect a desire to elevate those around him, and to deflect the focus onto others—a leader who stays in the background, and a teacher, mentor, and role model who spotlights the talent he's working with. When discussing collaborations, he often speaks of channeling, of holding a mirror to help others see themselves. This is perhaps one of Pharrell's greatest gifts to a creative enterprise: he meets people where they are, then guides them toward their strongest and most fulfilling expressions. "I know my job," he has said. "I'm not a boxer, I'm a trainer."[5]

As the excerpts in this book reveal, Pharrell cares deeply about the future while actively shaping global popular culture today. In his public speaking, he often outlines our collective responsibilities in the fight for racial, gender, and economic equality. He expresses deep gratitude for what he has achieved and has been given, yet he insists that advantages and opportunities must be put to good use. "Privilege is a superpower if used to restore equality," he has said.[6] He is in many ways a feminist, uplifting women in his public speaking and philanthropic activities, and, in one particular case, with a leather jacket bearing the words "Women's rights."

Pharrell is deeply aware of his position as a cultural figure, the power that attaches to it, and the potential for doing good. He sees himself as part of a broader vanguard of cultural figures with similar aims. Music, he says, "is an incred-

ible power, and I am deeply grateful that I can write songs that communicate with people all over the world."[7]

<div align="right">

LARRY WARSH
NEW YORK CITY
JANUARY 2023

</div>

1 India Ross, "Joopiter Ascending," *Financial Times HTSI* magazine, October 1, 2022, 33.
2 (52)
3 (33)
4 (21)
5 (32)
6 (52)
7 (4)

Pharrell-isms

Life, Family, and Faith

I love Virginia. I grew up in Virginia Beach. (52)

———

I grew up in these apartments called Atlantis
Apartments. Seriously. And it was probably
the most fun I ever had in my life. (29)

———

I stopped eating fast food. But when I was
a kid a Happy Meal was my world. (23)

———

[Football was my favorite sport growing up,]
but I never played on a team. Band was the
closest I came to playing a sport. (14)

———

My favorite book when I was a boy was
The Cat in the Hat. (23)

————

I've never been a tough guy. (32)

————

[Skateboarding] was just a strong part of my
growing up. I was in the projects until age
seven, and then my family moved to the
suburbs. And all my friends were skating. So
by the time I turned thirteen, I had a haircut
with, like, a billion parts cut in my head and
checkerboard slip-on Vans so people would
know I was into both hip-hop *and* skating.
I was walking around saying "rad,"
and then the next sentence would be,
like, "word." (20)

————

In terms of my formative years, I'm the sum of all those variables in my environment: my parents, my grandparents, the neighborhoods, the people, the economy, the community, the drugs that were going on in that time, the music that was happening, pop culture— I'm the sum of all of those things. (30)

———

As you grow older and you learn about life and nature, you start to demystify things that you didn't understand as a child. (38)

———

All of us as people, we're a result, a result of our choices. … But for the plight of the African American, and the African diaspora, we have had additional layers to what is our result. (8)

———

Our biggest issue as African Americans is that we don't really have a voice. (8)

———

This is our chance to lead, to truly embrace the importance of Juneteenth and treat it as a celebration of freedom that [B]lack people deserve. ... This is about proper recognition, it's about observation, and it's about celebration. This is a chance for our government, our corporations, and our citizens to all stand in solidarity with their African American brothers and sisters. (44)

———

I'm going to teach my son what it means to be himself, and a huge part of who he is, is being Black. (14)

———

I'm more of a family man [now] than I ever was. I always said that I was gonna have, like, four kids. I didn't know I was really gonna *have* four kids. (5)

———

It's a full-time job being a husband. It's a full-time job being a dad. (8)

———

It gives me great comfort knowing this generation is the first that understands that we need to lift up our women. (50)

———

Let me ask y'all a favor. On three. ... Can you
guys just say: "Women are the answer?"
All right? (51)

———

[Learning about my personal familial links
to chattel slavery in America] puts a very
vivid, intense context behind what it means
to be African American. And I thank God that
I got to hear it, but I'm so sorry they went
through this. ... I have to say I'm
forever changed. (18)

———

Virginia, like the rest of the country, has a complicated history—a history that continues to shape the present. The first enslaved Africans sold into bondage in North America stepped foot on our soil exactly 400 years ago. (52)

The universe is so much more grand than anything I could be or do, and so I'm lucky to play a part in it at this time. (30)

My greatest fault in this lifetime is that sometimes I'm too zoomed in. [Sometimes] you gotta zoom out, you gotta have a bigger picture of things. (32)

I'm like this old cartoon called "Mr. Magoo";
he's like this short old man that just kind of
keeps on walking, and it's not really clear as to
whether he's blind or he just has his eyes
closed. But he walks into all kinds of things
that should be calamitous, but nothing ever
happens to him because he just uses his
instincts to keep going. That's who I am.
I often don't know where I'm going. (17)

———

Self-awareness is a muscle that needs exercise.
It needs a regimen. (40)

———

We are all on a journey of self-awareness. (40)

———

Humility is a skill set. It's an art form.
It's something you work at. (37)

The world needs you in your purest,
most honest form. (39)

I never knew who I was gonna be.
I still don't know who I am. (30)

It's one thing to realize what kind of [chess]
piece you are[;] it's another thing to realize
where you belong [on the board]. (30)

I am a perpetual optimist. (30)

———

I am a bicycle, not a four-wheeler. I'm
meant to ride, but there's only so much
weight I can take and there's only so much
terrain I can take and I can only go so fast.
I'm very clear on that. (37)

———

If you asked a fish "Is there such a thing
called water?" they'd argue with you. (15)

———

When you look at all of the activity that's going on in the universe, there is a spirit that comes from that movement, too. That's the spirit that I respect, 'cause it's greater than me. It was here before me, it's gonna be here after me. So I respect that. To me, *that* is God. (30)

———

I know my job. I'm not a boxer, I'm a trainer. (32)

———

For me, it always comes back to Virginia. (52)

———

Art and Creativity

From the start, I chased my curiosities. ...
When I was young, I thought I knew
everything. Now, I'm not sure
if I know *anything.* (25)

———

Why create? Because if we don't, we're
no different than the fish. (15)

———

Our imagination is where all of our
conversations come from. (57)

———

Intuition and prediction are two
different things. (5)

———

On a more paramount level, everyone is a creative. Everyone that makes a move or does anything in life is a co-creator. (36)

———

People always ask me what inspires me, and I always say: "That which is missing." (15)

———

I mix things together all the time. (15)

———

Characters are always the ones that I'm able to give context to. Mona Lisa was a character, but da Vinci was able to put the track behind her that made her face make sense. (32)

———

A lot of songs that I ended up doing for myself are songs that I wrote for other people. They were better songs when I was thinking of those people and not myself. (27)

———

It all goes back to pop, to this desire to communicate your ideas to a broad audience. (56)

———

Art is expression. And the art of art, the power of art, what gives art its pertinence, is when people are pushing it. (5)

———

It's the same reason why I enter any platform or artistic discipline. It's because I feel like maybe I might be able to offer a unique point of view that doesn't exist, which is usually the motivation for me to enter any kind of space. If it doesn't exist, I'm inspired to check it out and see where it goes. (6)

———

If people gave you red paint and blue paint and a canvas and paintbrush and said, "Paint me something," they'd probably expect demons and a Smurf. But why can't I just mix the colors together and make purple? Or why do I even have to use the brush? Why can't I finger paint? Or why do I even have to use the canvas? I just think that people expect us to be limited in our thinking, but I don't like to look at the world that way. I see a world of blurred lines and limitless creativity. (20)

———

That's instinct ... the ability to exercise your instincts in a way where your animal instincts overrule common sense or logic, to not be reasonable. And to still have a thing in you that allows you to be pragmatic and solve the situation when a crisis hits.

That's next level. (58)

———

I'd always thought that music was separate, art was different, clothing was different. But as I got older I realized that it's all the same thing. It's just a different language. For me, music has all kinds of colors, you know? Just like clothes have all kinds of colors, or design uses all types of colors. And different combinations make us feel in different ways. (58)

———

There are many different forms of synesthesia.
There are grapheme synesthetes, people who
see colors in numbers, letters in colors. ...
I believe most musicians and most
artists are synesthetes. (48)

———

Each project that you do, you just have to get
in and pretend that you have nothing else
going on and that this is the most important
thing to you and your life and you'll make
good, instinctive decisions. (7)

———

In order to do great things, you must be unafraid to detach yourself from where you think you've had some interesting successes, because you've got to re-create yourself again and you can't do that holding on to a glory from yesterday. (57)

———

At a certain point you realize it's okay to march to the beat of your own drum, being careful that you're not on a planet of one. As long as you can figure out what you do very well and continue to tackle different subjects and continue to go on new frontiers, like in *Star Trek*, you just go. (27)

———

Creativity is the work of the universe. (8)

———

Artists are like messengers. (29)

———

Our job as artists is to be honest about
what we're feeling. And what we're feeling
is not always going to be perfect. Sometimes
it's going to be controversial. Sometimes
it's going to piss a couple of people off.
Sometimes it's going to motivate people.
[And] sometimes it's going to inspire. (29)

———

I draw inspiration from everything. ... It can
be just a word or an image that makes me
think of something and then it takes
off from there. (4)

———

We share the same words, but the way
you arrange them is your identity,
your personality. (57)

———

A lot of my creativity is a gift, but without
discipline you're never going to
get anywhere. (4)

———

It takes more than just talent, it takes drive.
(30)

———

If you have the compulsion to be creative,
that's awesome. But if you don't, that's not
a reason not to be creative. (15)

———

Age is simply just a number. If you have a
great idea, and you assemble the right team
around you to bring it to life, you
should go for it. (7)

———

That's really all you need to be an artist,
to have [a] perspective, and to be a fine artist
is to have the skills, the muscle memory
and the motor skills. But you have to have a
perspective, like [gallerist Emmanuel
Perrotin]. He may not be able to paint shit,
but he definitely, he's got the eye, you know?
And he knows it too. (58)

———

The only thing you can do is be loyal to your
creativity and try to do something new and
fresh, and leave it at that. (12)

———

A good film is defined by how you feel when
you walk away. Music is the same thing. (26)

———

I'm not mainstream at all. I can make
mainstream music and I make music for
mainstream artists, but me, myself,
I'm not mainstream. (34)

When that [Daft Punk] record came out,
that was super awkward for me, like really
awkward, because all the time, and still to this
moment, I still consider myself a producer.
You know, like one day I want to be like
Quincy Jones, one day I want to be like
Dr. Dre or Teddy Riley, I want to be like
those guys. I'm still not seeing myself
as an artist. (29)

[Mixing] was always my thing, you know? Mixing things that hadn't previously been mixed together before. Music is the same way. If you notice, that happens in all art forms of our submodality. For example, you're talking about mixing genres together, right? Well, it's the same thing with food. Believe it or not, there was a time when no one had ever tasted peanut butter and jelly. Or chocolate and peanut butter, like a Reese's Cup. There was a day when that did not exist, and people who were chocolate purists would be like: "Never." People who ate peanut butter would be like: "Get the fuck ..." But those two together, Whoa! (27)

———

Any art form you name, when you mix two things that seem like they don't go together and do well, when you do it in a really profound, prolific way, it becomes timeless.

(27)

———

I draw enjoyment from the process. When it begins to feel like work and is less explorative, less of a journey, that's when it's no fun. (58)

———

To me the artist is like the most important energy in the room. If they feel like they have to compete with you then they're never going to give you the best version of who they are.

(29)

———

Creativity without business is usually victimization. And business without creativity is a waste of fucken time. (8)

———

I think all artists should be compensated. But I think that's not why we do it, right? We don't paint for money or make music for money. (58)

———

There's so much talent where we come from, there's so much talent. All we need is some of these bigger corporations to recognize some of that talent and bring 'em in. (15)

———

Your first job as a producer is to make them ultra comfortable in an environment where they, you know—produce the conditions to make them feel as comfortable as possible so they give you the best version of themselves. (29)

———

I don't want to just be purely creative. I want to be creative, but at the same time I want to be a leader to young kids, to let them know that you can do anything. (7)

———

Art is largely diminishing throughout the curriculum throughout this country, and we need to protect the creative mind. (36)

———

We need people … to consider the idea
that these kids have latent talents, but they
just need the opportunity for someone to
recognize that there could be something there,
scratch the surface a little bit, pull it up,
and give them some hope, let them
use their ambition. (15)

———

I want all children to have access to creative
growth, access and support. All kids,
not just my own. (36)

———

The average kid [today] knows who [Takashi] Murakami is. The average kid knows who Jeff Koons is. In science they know Neil deGrasse Tyson is, and Michio Kaku. They know everyone now. (7)

———

You gotta find something that moves your emotions—not just occupies your mind or bides your time. You've got to find something that you emotionally connect with. I wish that for every child. (60)

———

Believe in your direction and do it. Spend less time talking about it and more time trying to perfect it and put it out there. And you know, if there's fire, the kids will sniff it out. They always do. And they'll turn you all the way up. (21)

———

We have the ability to do whatever we want. (32)

———

I think for anyone to be successful and dream big and do big things, you have to have a half a cup of delusion. You have to, or it's never going to work. You just cannot be filled with reality. It just is not going to work. (29)

———

We paint for the thrill of bringing something that did not exist before we did it. We make music because it's something new. You're creating these moments of discovery for people. When people hear that sound[,] it opens their minds up to things they may have never thought about before. (58)

———

My life is a workshop. (32)

———

I think that when you're curious, and you have the willingness to act on it, that's successful. (15)

———

If I'm curious, I'll work past time when it's time to go to sleep. If I'm into it. And if it feels like work, I can't wait to go home. (58)

———

How does a mirror see itself? (15)

———

I'm always fascinated [by] what will stimulate me next … colorwise, silhouettewise, tastewise, smellwise. That's purely what keeps me going, feeling something, seeing something, or hearing something and it making me feel a different kind of way. (58)

———

We don't make much happen when it comes to creativity. We're just antennas and transistors. We're speakers, you know. We're just lucky to get the transmission. (5)

———

I like to browse and just hang in bookstores. (20)

———

I don't want to blend in. (13)

———

I don't want to repeat myself. (7)

———

Creativity to me is a means of expression.
It's a gift from the all that is, all that was
and all that ever will be. (17)

———

You've got to continue to reinvent
yourself today, all the while thinking
about tomorrow. (57)

———

Fashion and Design

The body is a canvas. (53)

I always say that which makes you different
is what makes you special. So if you have
something that's different, then continue
to work on that and push that. (29)

Celebrate your difference. (29)

Fashion is everywhere now. And people
consume what they see, as if by instinct. (43)

I'm very interested in jewelry—I love to
wear it, I love to collect it. (47)

I met Takashi [Murakami] through [Japanese fashion designer] Nigo years ago. (38)

As soon as I met Nigo, I knew I wanted to be family. I recognized what he was doing as something I have felt my whole life. (41)

The most memorable thing for me is the culture that Nigo introduced me to. I learned a lot of new things that are important to who I am today. I met someone who believed in me and introduced me to new art, design, fashion, food. ... Some of the best food ever—I started eating sushi because of Nigo. (41)

Who knew if you just follow what it is that you're curious about, it may make sense for you one day—and in a major, major way. (33)

———

I wanted to work with [Louis] Vuitton because they take a regal approach in designing their products, and they love it. I learned so much and it is a wonderful experience to collaborate with them. I feel fortunate to be a student in the fashion world and have the opportunity to work with the best. (47)

———

The minute that I stopped worrying about what other people thought, and stopped catering to the fears that are taught to you— the minute that I let all that shit go—that's when I started, like: "Oh, that Chanel belt? I could wear that. That Chanel hat? I like it. I could pull that off." (37)

———

I'm happy to be able to express myself and be who I am. (31)

———

I am overly ambitious, because I realize it can be done. (59)

———

One of the things [the universe] has
given me is the ability to make things, to
reverse engineer a feeling and make
a tangible item. (5)

———

[African Americans] are the influence
for the music. We are the influence for the
sneakers. We are the influence for the art.
We are the influence for the slang. We are the
influence for the sound. We are the influence
for the dancing. We are the influence for
even our taste buds. But the problem
with all that: We don't own most of it.
We're not the owners. (8)

———

I was like a nerdy little Black kid on a skateboard. So looking at high-end fashion was something that I really didn't understand in the very beginning. ... And then I realized, slowly but surely, man, this is amazing. And although there's mostly the perception that it's for women, I just started to see, okay, as a man I can wear some of this. So I would wear sunglasses here, or a jacket there. (33)

———

I'm still a student. I'm still developing. I'm inspired by the influx of all the information that I have to study. My mind is exploding. But I'm learning so much, and I'm so excited by it. It comes out in my music, it comes out in any design that I'm doing—it's food. Never stop learning. (19)

———

[Billionaire Boys Club] means the ripening
of my taste buds and personality. (41)

———

Rei [Kawakubo] is a complete genius. (53)

———

I really like Yohji [Yamamoto], and I like
[Junya] Watanabe too. (53)

———

Tokyo is my second home. ... The way
the Japanese regard matter, flesh, spirit, and
technology, to me, is unmatched. ...
I love Tokyo. (55)

———

[France] speaks to me. It just does. (56)

———

It's mind-blowing to work with people who are great thinkers and are not afraid to execute ... no matter how crazy. (41)

———

When I design something ... it's about bringing convenience and creativity and considering the human condition. (19)

———

I don't [design a chair] because I think I am going to turn into a famous furniture designer. I do it because I'm actually interested in it. (38)

———

For me, any category that we step into, we want to make it better than the way we found it. (6)

———

I just wanted to say that from my point of view ... [Karl Lagerfeld] has changed the world. (43)

———

I am inspired to create by travel, places, spaces ... and by good conversations with forward-minded people. (41)

———

[Zaha Hadid] happen[s] to be my favorite architect ... [a]nd favorite designer. (53)

———

What defines good space? Good architecture?
Good urbanism? (53)

———

The only thing I can do is just bring my
instinct, what it is that I'm feeling, and just
be super candid and artistic. Whether it's my
sketches, or notes, hunches, instincts,
[I just try to] be as vivid as I can. (15)

———

I just want to do what other people are
not thinking about. 'Cause there's so much
right under our noses. (15)

———

I love what the Eames family did together,
Charles and Ray. I thought they were
just genius. (9)

———

Every time that you see a device or you
see something that you like, that you
use, or that you depend on, you have
a human mind to thank for that. (15)

———

Necessity is the biggest inspiration for me. (7)

———

When you listen to yourself and you're
comfortable in who you are, you wear what
you feel like fits and looks right on you.
And that's it. (37)

———

Collaboration

I'm very loyal to the people I partner with. (32)

Knowing that you did your best. I think that's
what you should do in any collaboration.
Anything that you do, you should
rise beyond above. (6)

Everything is about people working together.
(8)

When I do stuff for other people, that allows
me to channel things for them, and so the
universe set up the perfect conditions to get
me to write a song like ["Happy"]. That
made me cry. It literally made me cry. (37)

You just gotta trust that someone sees
something that you can't see. (5)

———

Oftentimes, I take off my ego hat when
I'm in the studio. (5)

———

Challenges and NOs make you stronger. (7)

———

Can you imagine if the art community
actually loved each other and supported
each other? (28)

———

My job is to nudge you, to poke and prod,
and pull you in places that you would not go
so that you can get a different result. (5)

—————

There are a lot of geniuses out in the world.
And I'm not [one]; I'm just kinda someone
who pays attention to the empty space
of curiosity. (7)

—————

All of my work is a direct reaction to meeting all these very interesting people with whom I've collaborated. I've learned so much about their processes and who they were, and their vibes have inspired me. In that case, I just could not take authorship for my path. I know that I've elected to take some of the choices, turns, and the direction that I've taken. But I know at the same time, there are these integral people in our lives from time to time who come in, give us direction, and guide us. They tell us which way to go, and those are the people I feel like are just as much. ... They share the authorship for all of my successes. (26)

———

There's an appreciation for good taste. You respect people with good taste. And so that's how I am naturally. I just respect people that I feel have this innate sense of sophistication, whether they're artists or not. (56)

———

The idea that rock and rap could come together is timeless. You look at all the rap records right now. It's a lot of pop-punk melodies in there. Timeless. Run-D.M.C., thirty-something years ago. Timeless. … Streetwear and high fashion. It's timeless. (27)

———

I feel like I'm an apprentice in all areas. When it comes to music, fashion, footwear, design, in all of these areas I feel like a novice. (15)

———

There are a lot of things that we take for granted. (6)

———

Failure hurts pretty bad. It hurts pretty bad. But when you got good people around you, they remind you that failure is actually just a lesson. It's how not to walk so you don't fall again. (29)

———

Collaboration is like a crash course most of the time, when I'm learning something new. It's like a crash course into whatever item, object or artistic discipline that we're working on at that time. It just allows me to learn. I've learned so much in collaboration. (17)

All of my biggest songs were songs that I did with or for other people. Collaboration has always been part of my DNA. And, to be clear and to be honest, songs that I ended up putting out by myself were always songs that I wrote for other people. (17)

Every time I go [into the studio] with Kendrick [Lamar], he transforms. But he gets that. He knows he's his next man. He's super clear about that. (5)

———

The key to any process is when someone believes in you. Believe, trust, and faith are like air to personality. When people say really nice things about my work, I'm always conscious and remind people that I am only as fast as the wind that's blown into my sails. (38)

———

[Hans Zimmer has] been incredibly generous
to me and my career. The most valuable part
of our friendship is that he doesn't mind
sharing gems about the craft with me.
That's something I can never pay for.
It's invaluable information. (12)

———

You have to divorce your ego as soon as
you hit the doorjamb of the studio. You have
to leave it. Because if you bring it in with
you, then you'll make decisions based
on your past success, or what you
think is the only way. (7)

———

One of the fortunes of life is to experience the work of great minds that have done amazing things. To not only be able to enter a conversation with them but to do things with them and learn their process, learn what makes them tick. (38)

———

What would the Pharrell-produced, Prince project [sound like]? What would be different about it?

Maybe it would be interesting to have [heard] him do, like, Afro-Cuban. (5)

———

When you're a music producer, that's what you do. You listen to a track; it blows your mind. And then you try to make it even better.

(52)

———

You don't have to be the one with all the answers … when you're willing to work with other people who are amazing and who can help you up your game. And … to me, the beautiful part about being in the Aquarius age is that there's a lot of sharing and there's a lot of otherness and there's a lot of people being helpful to each other. And that's what we want with Black Ambition. We want to foster real, true elevation, enlightenment, and growth. (8)

———

I'm an Aries. So, you know I'm a fighter for
what I really, really, really believe in. But man,
NO is so good and so powerful. (30)

————

You need some NOs.
NOs make your YESes sharper. (30)

————

My work isn't the biggest, it's not the best,
but it's mine. Me and my partner, Chad Hugo,
we're blessed guys. (20)

————

We developed our sound after we made
"Superthug." (32)

———

Loïc [Villepontoux] is my right hand. (38)

———

I'm just doing as much as I can—that's what
you're supposed to do. Life isn't just about us.
It's about others. (19)

———

We're far from experts. We just cared
enough to do the homework. (6)

———

I noticed there was this collective consciousness that was happening around [N.E.R.D.] and that we were attracting, and I was like, "I gotta do something responsible about it, I've got to figure out a way to get these kids visibility." (7)

———

I only want to do partnerships where I get to be creative and the business is right. (8)

———

The recurring message that we put out is that you can do anything you want to do, and you can be anything that you want to be, and you should be unafraid to do such. (7)

Jay-Z gets it. He's always gotten it. People don't realize he's been making records since the eighties; that's unheard of. (5)

———

A good idea is literally just that, until you have a team to help you manifest and bring it to fruition. (7)

———

Every time you are moving or thinking while you exist, you are cocreating. (15)

Music and Business

Music is the key, the skeleton key that's
opened every door for me. (5)

———

My all-time favorite song changes all the time.
… I think my favorite experience with a
song has been "Happy," but that's
because of you guys. (23)

———

I like doing what hasn't been done. That's
what really perks up my ears. These atonal
sounds become musical once you hear the
entire ensemble. It's a new way of listening
to music. Your ears detect these funny tones,
they start to catch the rhythm and they
start to form a mosaic. (57)

———

When I was a kid, my mom and grandma would listen to Tramaine Hawkins, Andraé Crouch, James Cleveland, Aretha Franklin, and the Mighty Clouds of Joy. (14)

———

The music was everywhere, it was like air, it was like you go outside to hear music, you are in the house, someone's playing music. Music was just like second nature. (29)

———

Name an artist you liked from childhood.
Stevie Wonder. (5)

———

I'll never forget where I was when I heard
"Rock the Bells" for the first time. (5)

———

Music brings people together. Music is a force
that reaches people wherever they are and at
any time. Nothing gets in the way because it's
able to fill up all the space around us. (4)

———

Songwriters are the empaths among us,
providing the soundtrack to our emotional
coming of age. If there was ever a time for
an explosion of empathy, it is now—just
turn on the news. (45)

———

Music is an incredible power, and I am
deeply grateful that I can write songs that
communicate with people all over the world.

(4)

I've always been a little left of center.
But I think music helped me and other people
make sense of it. ... You're only crazy when
there's nothing to go along with it. When you
have these eccentric characteristics, it's more
accepted and understood when there's
something, some sort of skill set to
go along with it. (21)

I'm so lucky to be able to do what I do. There's countless musicians somewhere right now writing the best song that no one will ever hear. Just because everything is math, and there are odds. And so it's just not gonna happen for the most genius [musician]. So, who am I to have any kind of hubris? Or take any of this for granted? (30)

———

Songwriters show entire generations of us what falling in love feels like. Think about that song you fell in love to. People are still falling in love to that song today, right now. (45)

———

[Quincy Jones is] my mentor-slash-musical
godfather. (54)

———

Being young posers, we used to watch
Suicidal Tendencies and the Dead Kennedys
and we used to watch a lot of old
punk stuff too. (38)

———

When you hear a song, it takes you back to
that moment where you were when you first
heard it, or how the song makes you feel. (35)

———

When people really just pull from the ether and bring forth things that there are no audio references for … that's awesome. That's all I ever wanted to do. … It's all about pulling from nowhere and being happy that you can just put it into shape when it comes to you.

(57)

———

Philly is where emcees are born. They just grow [there]. (32)

———

Collaborating with a musician is like a
conversation: each experience is
unique to that person. (12)

———

As a producer, I want to make sure every time
I do something, there is a moment in the song
where you go: "Whoa! Wow!" And if we're
not doing it, what are we doing it for? (60)

———

"Superthug" made every hard rapper at the
time look at us very differently. ... Because we
worked with a hard rapper? No. Because
we worked with a hard character. (32)

———

You can copyright that which is tangible,
not the intangible. (5)

———

The problem is that the generation in power
does not recognize change. … The value of
music has been redefined. It's not really about
buying albums. It's really about the music
accompanying something else, some other
sort of experience. In the way we build, we
are, as a species, turning inwardly more and
more, catering to our emotions, rather than
doing things for the greater good. (38)

———

A song is authored by you, but its
interpretation is owned by other people.
And you have no control over that. (29)

———

Here is something you might not know about
me: I love science. But nobody has mastered
time travel and teleportation like songwriters.
Their songs can transport us to a precise time
and place better than any technology so far.

(45)

———

If you don't understand where [hip-hop is] coming from, you really don't understand why it's necessary to support it. (5)

My music is about equality, and being associated with the idea of equal got me where I am now. (25)

I do something that people can't see and touch. You can hear music, but you cannot physically stick your hands out and feel it unless you're standing in front of a speaker, which is a transmission and a simulation, but not the real thing. It's like God or the wind. (20)

Steve Jobs created the iPod and iPhone, generating *trillions* of dollars in value and changing the world. I ask: What would that value be without the songs you play on those devices? The songs, written by songwriters, inspired the creation of the most popular tech products of all time. (45)

———

No one should own you, no one should own your actions, no one should own your creations, [no one] but you. (8)

———

We work in a business where it is okay to own other people's masters. That's insane. ... That will soon change, by the way. Everybody should own their masters. If major labels want to do deals with artists to partner with them, great, then partner with me—but don't own me. (24)

———

You should be your own master. Period. You should be your own master of your creations. (8)

———

Snoop's always been that guy who's like: "Take me there. I trust you." (32)

———

LL Cool J was the coolest; he had the
crazy chains. (5)

If you listened to music that was on
SoundCloud, there are no hooks. There's just
vibes. That made me think to myself, I don't
know if I want to hear a traditional song
structure anymore. (60)

[N]ow artists are blowing up bigger and in
a more viral way online than being with
a record company. (38)

You can't copyright a feeling. (5)

———

There's a whole university of science between
what's being played and what you're hearing.
(5)

———

The last time a song fucked me up was
"Them Changes" by Thundercat. When I
heard that song, it was crazy! (60)

———

Doug E. [Fresh] is everything! (32)

———

I swear by Q-tip. I swear by Donald Byrd, or
Roy Aires, or Stevie Wonder, or Donald Fagan,
Steely Dan, the Doobie Brothers. I swear by
those dudes. There's so many—Earth, Wind,
and Fire. I swear by the stuff that they do. (21)

There is a lot of energy out there, and it's
up to each of us to use it. Music just
happens to be my channel. (20)

Music is a universal language. (15)

They did a lot to try to suppress [hip-hop music], but the white kids loved it too much. And I hate to make it racial, but that's what changed it, right? We've been professing our love for it. ... They couldn't suppress that; it was just too big. It was just too strong. It was too beautiful, and it was igniting people in a way. (5)

———

Drake's amazing, and Drake is all powerful and he's so talented. (32)

———

Slick Rick, you're the king. (32)

———

Really, our generation's greatest producer
of all time is Dr. Dre. (32)

———

Chad [Hugo] is a genius. He is musically that
guy [who] can play any instrument and he's
done so much and is capable of so much still.
Like he's just probably one of the most genius
musicians I've ever met in my life. (29)

———

Timbaland has always been better than me.
Period. (32)

———

[Stevie Wonder's] reggae was amazing,
his disco was amazing, his ballads were
unbelievable, his Parisian, Burt Bacharach
Bossa Nova stuff was amazing. (5)

———

To me that behavior on stage—that erratic,
crazy, sporadic, jumping up in the air, inciting
the mosh pits in the crowd. That is just as
much a part of the song to me as the lyrics.

(38)

———

Chris Lighty had the vision! (32)

———

[The Ramones] were really good at
their thing. (5)

Thundercat is the most underrated,
illest bass player. (60)

[Hans Zimmer] goes left, he goes right, he
goes up, he goes down, he goes diagonal, he
goes fourth dimension, he comes back. That's
the best thing[;] it's the fact that you can't put
your finger on where he's going to go next.
He is consistent in that. He just reinvents
himself. That's what I want to do. (57)

I think I get blown away by chord
progressions that make me feel something
that I've never felt before. (5)

———

*Is there a record that you've ever heard and said:
"I wish I could have made that?"*
A Tribe Called Quest's "Lyrics to Go." (32)

———

I'm jealous of [Jay-Z's] "Lucifer,"
I have to say that. (42)

———

People just get programmed by what the media puts out in terms of trying to cast people as one thing or the other. (20)

———

My question is: What were those guys feeling? What was Grand Master Flash and Melle Mel feeling when they made "The Message"? (5)

———

I wouldn't be doing what I'm doing right now if it weren't for Q-Tip. … That guy, still to me, is like everything. (22)

———

Failure is not always a bad thing. You just
have to be smart while you're in the
middle of it. (29)

———

For me, music is my number one ... [b]
ecause that's the first thing that taught me
about the layers that affected my life, you
know? Music to me is just like a bunch
of layers, and when they work together,
ey stimulate you. (58)

———

To me, chords are coordinates. ...
They send you to a place. (5)

———

Prince was so cool. I tried for years to
make records for him. (32)

———

Songwriters have challenged us to be our best
selves: to "Give Peace a Chance," to "Fight the
Power," to believe that "We are the World,"
but still ask "What's Going On?" (45)

———

When we have felt fear, songwriters
have taught us bravery—when dealing
with sexuality, gender identity,
and acceptance. (45)

———

Music is always my baby. (19)

———

You can spend two days talking about the business of music, but let's not forget, without songwriters, there is no business of music. (45)

The most valuable lesson that I've learned [about the music business] is that it's music *business*. (8)

It's not a fabric when there's only one thread. You must consider all of the threads that make it up for it to be a fabric. And that's what we are. The music industry is really one big quilt. (57)

Education and Social Justice

I hate politics. (30)

Our Constitution was flawed before
the ink dried. (49)

I try to be a politically engaged citizen and
do my best to face social injustice. ... I hope
through my music I can also offer support
to those who need it and do whatever I can
to fight for important causes. I'm not a
huge activist but I try to play my little
part. I also want to encourage my
fellow artists to get involved. (4)

You need to ask yourself, what can you do
within yourself to contribute to change? (19)

———

It's your self-awareness, it's your vision,
it's your privilege, and it's your empathy that
will guide you to the right answers. (52)

———

Empathy, combined with an awareness
of privilege, is a game-changer.
A superpower. (39)

———

Gender bias is *so* real. But yet,
so seemingly invisible. (3)

———

In this country, women didn't gain the right to vote until 1920. (52)

———

Women didn't get control of their reproductive rights until 1973. And those rights are under attack every day across America. (57)

———

We ended slavery—you would think we'd be tired of telling other humans what they can and cannot do with their bodies. Haven't we learned our lessons about trying to govern human bodies? (52)

———

This is the first generation that navigates the world with the security and confidence to treat women as equal. (50)

———

The truest definition of masculinity is the essence of you that understands and respects that which isn't masculine. (37)

———

Women are the greatest gift to us; they actually give us life. I don't understand hating women in any way, shape, or form. (32)

———

I fully realize the power of women. (25)

———

Imagine the possibilities when women are not held back. (50)

———

Whether you prefer statistics or anecdotes, it's clear that ending slavery wasn't enough. Racism simply migrated from the American slave system to the justice system. The health care system. The financial system. The housing system. The education system. It infested everything. Every institution. Every branch of government. A country with a foundation in racism can easily slide into all forms of discrimination. Once again, whether you prefer statistics or anecdotes, we are a nation divided. (52)

———

It's not possible to achieve—to truly achieve—equality, in a matrix that was written by and for a double standard. That's just not possible. (30)

———

Women, LGBTQ, teachers, and the poor are fair game for the oppressors. Even our own high school students are falling prey. You know the oppressors are entrenched when anxiety-inducing active shooter drills at public schools seem like the most viable solution to protect our children from gun violence. (52)

———

We're disconnecting from each other even though online we're probably more connected than we've ever been. It's a bit like the Tower of Babel, if you will. (10)

———

We cannot let the algorithm continue to distract and, even worse, *divide* us. Because it is. Algorithms have no conscience, but you do. Outsmart the algorithm that's manipulating your newsfeed and life. You are smarter than that. (52)

———

Displaced anger is a brushfire and the media is the wind. We've got to find some real water to put out that fire, and for me, the answer is love and unity. For every individual who gets killed, someone should build a school or teach a child. We really need to balance things with positivity. (14)

———

The reason I share these reminders is because I know it will only motivate you more. It will ignite your spirit to *be* the change, to drive distinction between your generation and those of the past. (52)

———

I think the universe puts us in this position because it knows that we're gonna give back. It knows that we are gonna take our experiences and share the codes with our other brothers and sisters. (32)

I'm just trying to give everybody the codes. (46)

For me, it's fundamentally about education. In all of my experiences, in all of my travels, I keep coming back to education as the answer. Education is the death blow to discrimination. Equality is achieved via education. (52)

America's education system is failing a lot of people, but especially African Americans. To me, any legitimate conversation about reparations starts with education. (52)

———

Far too many Black children still receive a second-class education in neglected, underresourced schools. And even when they do graduate high school, they can't afford college. (52)

———

There is no humanity without education. There is no education without demand. (50)

———

Let us protect teachers at all costs. (52)

———

I am a huge advocate for inner-city kids getting out and seeing the world, because it changes you. And you realize the little perimeter that you dwell in is so small, and it's basically a jail. (7)

———

One of my biggest agendas is to make sure that inner-city kids become more acclimated with technology. (7)

———

The most common point is connectivity and education. (11)

———

It's one thing to be "woke"—and have the knowledge. It's another thing to be *awake*—and to be actively engaged, leaned-in and doing something about what's wrong. (40)

We are seeing an entirely new generation of leaders emerging right now and they are potent. (44)

You see, I am not a leader. I am certainly not here to lead you. As a matter of fact, you are more likely to lead me someday. (52)

So I'll boil this down to three things to take into your college years and beyond.

Number 1: Use your superpower combination of traits—privilege and empathy—to make the world a better place for everyone.

Number 2: Continue the legacy and brave work of the strong women who came before you. They've kicked the doors open for you. Don't blow it.

Number 3: Let what is inside you guide you. Find your edge. Stay other. You are our most precious natural resource and the establishment is set up to deplete you. Don't be depleted. (39)

———

When I look out, I see thinkers, innovators, rule breakers. I see ambition. I see energy. I see bold, audacious dreams that are bound to disrupt. (52)

———

There's nothing that can outdo the energy of someone positive, someone with great intentions, someone that knows what they're talking about. (11)

———

Don't take the idea of self-awareness lightly. It is key to our collective success. (40)

———

Just imagine how much more we could
accomplish, how much more we could be,
if everyone could pursue their dreams
unhindered. If everyone was free to be
who they are, humanity would be
completely and incredibly unstoppable. (52)

———

There is no turning back.
We are only moving in one direction now.
Forward, to the future. (44)

———

Inspirations

I'm a creature of habit, but I'm also a creature of energy and curiosity. And if I'm interested in it and I'm curious about it, then I'm there for it. And I suppose I just don't have time for anything else. (27)

———

Somebody once asked me what inspires me, and I said: "All the things that don't exist." (57)

———

My closest friends are bishops and prophets. I want somebody that can tell me something that I can't see. (8)

In all creative people there's a tad bit of delusion. You kinda got to believe it a little bit in order to stick with it. (30)

———

If you believe that there is a skein of time, or if you believe that time can be measured by space and space can be measured by time, then that means that everything that we do is recorded in some way, shape, or form. (17)

———

I think pressure comes from having to face the idea or notion you could fail. And there's a lot of people who spend time doing that. (32)

———

Failure honestly can be like the best lesson and it's like the one that like God wants you to really pay attention to. That's why it hurts. The pain will help you remember how not to walk, what directions not to go. (29)

———

Fear is not a good thing, so I try not to experience it. It's like a straitjacket on your creativity. I always think that I would probably be better off using the energy I'd put into being fearful to think of something incredible to create. (20)

———

I am forever a student. (50)

———

The world has been like a teacher to me. (7)

———

When you've got a library card that works,
[you've got to] use that card every day. (8)

———

Most of us are just trying to do the right
thing and live good lives. We want everyone
to live good lives. (52)

———

[Growing up] I definitely was a little left
of center, and a little odd, but music was
like my inner sanctum; that's where I
found my peace. (21)

———

I want this for everybody. I want everybody
to wake up every day going: "How did
this happen? I love doing this." … I love
doing what I'm doing. I want that
for everybody. (5)

―――――

Privilege is a superpower if used to
restore equality. (52)

―――――

Success is relative. (15)

―――――

I sometimes think of life as a ladder. And at every rung of the ladder, you get to a place where you have to make a decision. And oftentimes some of the decisions that have the greatest impact are the ones where you have to make a split-second decision, where you don't have time to ask anybody for advice. (46)

We're all dealt these cards in life, but the cards in and of themselves don't read one way or the other. It's up to you to home in and cultivate whatever you've got in your hand. Most of the time, I see what I see, I search my feelings, and then I make my decisions based on my gut—and I don't always make the right ones. (20)

You don't know what the sunshine is until
you kind of get caught in the rain. (20)

––––––

Once you acknowledge that you're
insignificant, that's when the world starts to
speak to you. You start to realize, Oh my God.
How could you possibly think about trivial
things anymore? How could you possibly have
menial attitudes anymore? You start to just
look at life in a different way. (38)

––––––

The only way to make life better for yourself,
the only true and lasting way, is to make
life better for others. (52)

––––––

Empathy is the skeleton key to any room.
It's the number one thing that we
need before love. (17)

———

Once we know the plights of others,
we can't unknow it. (52)

———

It's an incredible aspect of humanity
to feel connected. (52)

———

When you empathize and you understand where someone's coming from, then you know how to reach them. If you don't know how to empathize, then you'll never connect with them. And that's about being human. It's about others. The human race. (6)

———

When they [were] singing a song [in my childhood church] you could feel the vibration. You could feel the vibration not only of the music, but you could feel the spirit; it's something that was just completely undeniable. (29)

———

I play for the human race. (1)

———

I feel like if everybody could just tap into their
empathy, then we could get to a better place.
Instead of pointing fingers, I want to help
point the way. (37)

———

I think if the world knew the vastness that
exists beyond our solar system ... they would
begin to behave a little bit differently. (54)

———

When you see something that needs extra
care, give it the care it needs. (52)

———

I believe in the universe. It was here before
us. It will be here after us. And for me, that is
divine order. That's what gives me faith, that's
what I have faith in. ... God is the greatest.
We'll be fine. (19)

———

Just take a second and live forever within
a moment of appreciation. (21)

———

SOURCES

1. "Adidas." In *Pharrell: A Fish Doesn't Know It's Wet*, edited by Ian Luna, 142. New York: Rizzoli, 2018.

2. "Exclusive Interview with Pharrell Williams | ULSUM." YouTube video, 6:23, posted by ULSUM, May 11, 2018. https://youtu.be/sLS6SHwCF6o.

3. "Hidden Figures: Pharrell Williams Interview." Vimeo video, 1:52, posted by SuperLuminal Films, January 18, 2017. https://vimeo.com/200052051.

4. "Interview with Pharrell Williams." Pirelli/World, March 8, 2017. https://www.pirelli.com/global/en-ww/life /interview-with-pharrel-williams.

5. "Pharrell and Rick Rubin Have an Epic Conversation." YouTube video, 47:57, posted by GQ, November 4, 2019. https://youtu.be/PnahkJevp64.

6. "Pharrell: 'It's about Others, the Human Race.'" Highsnobiety, March 2021. https://www.highsnobiety. com/p/pharrell-interview-human-race-skincare/.

7. "Pharrell Keynote at MIDEM 2010." Vimeo video, 41:28, posted by thecashmerethinker, January 23, 2010. https://vimeo.com/8935849.

8. "Pharrell Williams and Steve Stoute on Thriving in the Music Business and Black Ambition." YouTube video,

43:01, posted by UnitedMasters, May 13, 2021. https://
youtu.be/R7w9sub4v_Y.

9. "Pharrell Williams: Art D'assaut Interview." Vimeo video,
4:31, posted by BLAST, April 8, 2010. https://vimeo
.com/10773787.

10. "Pharrell Williams: Faith Is about What You Feel." i-D, June
10, 2020. https://i-d.vice.com/en_uk/article/m7jexy
/pharrell-williams-interview-i-d-magazine.

11. "Pharrell Williams: From One Hand to Another Shining
Stars InStyle." Vimeo video, 2:55, posted by Jake Campbell
Studios, June 11, 2015. https://vimeo.com/130464202.

12. "Pharrell Williams Interview." Time Out, November 21,
2016. https://www.timeout.com/kuala-lumpur/music
/pharrell-williams-interview.

13. "Pharrell Williams Masterclass with Students at NYU
Clive Davis Institute." YouTube video, 31:11, posted by
iamOTHER, March 21, 2016. https://youtu.be
/G0u7lXy7pDg.

14. "Pharrell Williams Talks Race, Black Women and Social
Justice." Ebony, November 13, 2014. https://www.ebony
.com/entertainment/pharrell-williams-talks-race-black
-women-and-social-justice-cover-story/.

15. "Why Create: Pharrell Williams Interview." Vimeo video,
31:16, posted by Flux, November 24, 2017. https://
vimeo.com/244341615.

16. 258Mafia. "Jay-Z and Pharrell Williams Have a New Single
on the Way." In R Report, August 20, 2020. https://www

.therreportmag.com/jay-z-pharrell-williams-have-a-new
-single-on-the-way/.

17. Brydon, Grant. "Stay Curious: Pharrell Williams Inter-
 viewed." *Clash Music*, July 9, 2018. https://clashmusic.
 com/features/stay-curious-pharrell-williams-interviewed.

18. Gates, Henry Louis, Jr. "Pharrell Reacts to Family History
 in Finding Your Roots | Ancestry." YouTube video, 5:00,
 posted by Ancestry, February 19, 2021. https://youtu.be
 /lwSC0ffg5iY.

19. Goh, Yang-Yi. "Pharrell Talks His New 'Barefoot' Sneaker,
 His Vision of Luxury, and Trusting the Universe." *GQ*,
 August 17, 2021. https://www.gq.com/story/pharrell
 -adidas-humanrace-sichona.

20. Grazer, Brian. "Pharrell." *Interview*, May 27, 2009. https://
 www.interviewmagazine.com/music/Pharrell.

21. Hard Knocks TV. "Pharrell Williams Classic Interview."
 YouTube video, 19:44, posted by hardknocktv, April 5,
 2021. https://youtu.be/1_uyhSu13ys.

22. Harling, Danielle. "Pharrell Williams Recalls Recording a
 'Trash' Verse for Q-Tip." *HipHopDX*, March 23, 2016.
 https://hiphopdx.com/news/id.38021/title.pharrell
 -williams-recalls-recording-a-trash-verse-for-q-tip.

23. Harling, Danielle. "Pharrell Williams Speaks with School
 Children about His New 'Happy!' Book." *HipHopDX*,
 October 7, 2015. https://hiphopdx.com/news/id.35776
 /title.pharrell-williams-speaks-with-school-children
 -about-his-new-happy-book#.

24. Hazel, Allison. "Pharrell Williams Talks Hidden Figures, Social Issues, and Music Business on the Breakfast Club." *Billboard*, December 12, 2016. https://www.billboard .com/articles/columns/hip-hop/7617749/pharrell -williams-hidden-figures-the-breakfast-club.

25. Hirschberg, Lynn. "The Art of Being Pharrell." *W*, May 7, 2014. https://www.wmagazine.com/story/pharrell -williams-interview.

26. Iandoli, Kathy. "Pharrell Williams Speaks Exclusively to *HipHopDX* on the Label of Genius." *HipHopDX*, March 3, 2014. https://hiphopdx.com/interviews/id.2307/title. pharrell-williams-speaks-exclusively-to-hiphopdx-on -the-label-of-genius.

27. Jenkins, Craig. "'I Don't Know What Myself Is': Pharrell Explains Why He's Better When He's Making Music for Other People, and His Songs That Defined the Decade." *Vulture*, December 9, 2019. https://www.vulture. com/2019/12/pharrell-interview-best-of-2010s-letter -to-my-godfather.html.

28. KAWS. "Foreword." In *Pharrell: A Fish Doesn't Know It's Wet*, edited by Ian Luna, 4. New York: Rizzoli, 2018.

29. King, Jason. "Pharrell Williams in Conversation with NYU Tisch and NPR Music." National Public Radio, October 29, 2015. https://www.npr.org/about-npr/452953953 /transcript-pharrell-williams-in-conversation-with-nyu -tisch-npr-music.

30. Live Talks Los Angeles. "Pharrell Williams in Conversation with Kenya Barris at Live Talks Los Angeles." YouTube video, 1:04:47, posted by LiveTalksLA, April 19, 2020. https://youtu.be/_brz9_L3FyU.

31. McLean, Craig. "Pharrell Williams: The Happy Man behind the Hit—and Hat—of the Year." *Independent*, October 17, 2014. https://www.independent.co.uk/arts-entertainment/music/features/pharrell-williams-9801704.html.

32. N.O.R.E. and DJ EFN. "Episode 241 w/Pharrell." *Drink Champs*. Podcast audio, 3:19:17, December 18, 2020. https://megaphone.link/HSW8527362338.

33. Payne, Teryn. "Pharrell Makes Fashion History in Chanel's First Male Handbag Campaign." *Ebony*, September 19, 2019. https://www.ebony.com/style/pharrell-chanel-male-handbag-campaign/.

34. Vaziri, Aidin. "Pop Quiz: Pharrell Williams." *SF Gate*, August 13, 2006.

35. Watamanuk, Tyler. "Pharrell Is Bringing a Human Touch to the World's Most Iconic Soccer Jerseys." *GQ*, October 22, 2020. https://www.gq.com/story/pharrell-soccer-jerseys-adidas.

36. Weatherby, Taylor. "Pharrell Williams Announces Yellow Ball Gala, Talks Protecting Artists and Taking a 'People's Stance' on Federal Arts Funding." *Billboard*, August 8, 2018. https://www.billboard.com/articles/news/8469193/pharrell-williams-interview-yellow-ball-gala-art-education.

37. Welch, Will. "Pharrell on Evolving Masculinity and Spiritual Warfare." *GQ*, October 14, 2019. https://www.gq.com/story/pharrell-new-masculinity-cover-interview.

38. Williams, Pharrell. "Dirty Jobs: A Conversation with Pharrell Williams and Ambra Medda." In *Pharrell: Places and Spaces I've Been*, edited by Ian Luna and Lauren A. Gould, 201–10. New York: Rizzoli, 2012.

39. Williams, Pharrell. "Greenwich Academy Commencement Address," Greenwich, CT, May 28, 2018.

40. Williams, Pharrell. "Harlem Children's Zone Commencement Address," New York, NY, June 27, 2019.

41. Williams, Pharrell. "Hearts and Minds: A Conversation with Pharrell Williams, NIGO®, and Toby Feltwell." In *Pharrell: Places and Spaces I've Been*, edited by Ian Luna and Lauren A. Gould, 57–63. New York: Rizzoli, 2012.

42. Williams, Pharrell. "In Bloom: A Conversation with Pharrell Williams and Jay-Z." In *Pharrell: Places and Spaces I've Been*, edited by Ian Luna and Lauren A. Gould, 9–11. New York: Rizzoli, 2012.

43. Williams, Pharrell. "The Iron Throne: Karl Lagerfeld, Interviewed by Pharrell Williams." In *Pharrell: A Fish Doesn't Know It's Wet*, edited by Ian Luna, 109–17. New York: Rizzoli, 2018.

44. Blistein, Jon. "Pharrell Joins Virginia Gov. Ralph Northam in Call to Make Juneteenth a State Holiday," *Rolling Stone*,

June 16, 2020. https://www.rollingstone.com/music
/music-news/pharrell-juneteenth-holiday-virginia
-1016177/.

45. Williams, Pharrell. "Songwriter Keynote: Pharrell
Williams," US Department of Justice, July 28, 2019.
https://www.justice.gov/atr/video/songwriter
-keynote-pharrell-williams.

46. Williams, Pharrell. "Knowing When You Know: Oprah
Winfrey, Interviewed by Pharrell Williams." In *Pharrell:
A Fish Doesn't Know It's Wet*, edited by Ian Luna, 8–15.
New York: Rizzoli, 2018.

47. Williams, Pharrell. "Louis Vuitton." In *Pharrell: Places and
Spaces I've Been*, edited by Ian Luna and Lauren A. Gould,
156. New York: Rizzoli, 2012.

48. Williams, Pharrell. "Mink and Ermine: A Conversation
with Pharrell Williams and Kanye West." In *Pharrell: Places
and Spaces I've Been*, edited by Ian Luna and Lauren A.
Gould, 213–15. New York: Rizzoli, 2012.

49. Williams, Pharrell. "Norfolk State Commencement
Address," Joseph G. Echols Memorial Hall, Norfolk
State University, Norfolk, VA, December 11, 2021.

50. Williams, Pharrell. "NYU Commencement Address,"
Yankee Stadium, New York, NY, May 17, 2017.

51. Williams, Pharrell. "Pay Me What You Pay Him: Taraji P.
Henson, Janelle Monáe, and Octavia Spencer." In *Pharrell:*

A Fish Doesn't Know It's Wet, edited by Ian Luna, 16–23. New York: Rizzoli, 2018.

52. Williams, Pharrell. "Pharrell Williams Addresses UVA's Class of 2019." YouTube video, 28:16, posted by University of Virginia, May 17, 2019. https://youtu.be /BwmHUuRkCQw.

53. Williams, Pharrell. "Third Culture Kid: Zaha Hadid Interviewed by Pharrell Williams." In *Pharrell: Places and Spaces I've Been*, edited by Ian Luna and Lauren A. Gould, 217–19. New York: Rizzoli, 2012.

54. Williams, Pharrell. "To Infinity and Beyond: A Conversation with Pharrell Williams and Buzz Aldrin." In *Pharrell: Places and Spaces I've Been*, edited by Ian Luna and Lauren A. Gould, 121–28. New York: Rizzoli, 2012.

55. Williams, Pharrell. "Tokyo Rising." In *Pharrell: Places and Spaces I've Been*, edited by Ian Luna and Lauren A. Gould, 174. New York: Rizzoli, 2012.

56. Williams, Pharrell. "We Are Your Friends: Pedro Winter and Sarah Andelman, in Conversation with Pharrell Williams (with Loïc Villepontoux)." In *Pharrell: A Fish Doesn't Know It's Wet*, edited by Ian Luna, 97–107. New York: Rizzoli, 2018.

57. Williams, Pharrell. "The Well-Tempered Clavier: A Conversation with Pharrell Williams, Hans Zimmer, and Ian Luna." In *Pharrell: Places and Spaces I've Been*, edited by Ian Luna and Lauren A. Gould, 19–24. New York: Rizzoli, 2012.

58. Williams, Pharrell. "When the Spirit Moves You: JR, in
 Conversation with Pharrell Williams." In *Pharrell: A Fish
 Doesn't Know It's Wet*, edited by Ian Luna, 185–95.
 New York: Rizzoli, 2018.

59. Wilson, Eric. "Pharrell Williams Has an Idea." *New York
 Times*, August 2, 2012. https://www.nytimes.com/2012
 /08/02/fashion/pharrell-williams-is-still-asking-what
 -if.html?smid=url-share.

60. Witte, Rae. "In the Studio with Pharrell: How SoundCloud
 Artists Changed His Approach to Music." Complex,
 December 12, 2019. https://www.complex.com
 /music/2019/12/pharrell-williams-interview-in-studio.

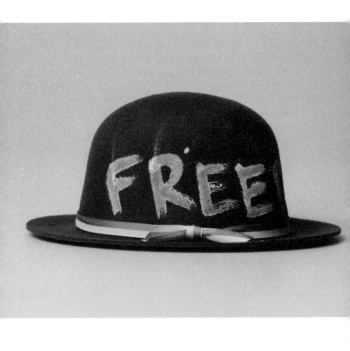

CHRONOLOGY

1973

Pharrell Lanscilo Williams is born in Virginia Beach,
Virginia, to Carolyn and Pharoah Williams on April 5.

1990

Williams and Chad Hugo form the Neptunes, their
first band.

1992

Wreckx-N-Effect's single "Rump Shaker" is released and
reaches number two on the Billboard Hot 100. Terry
Riley's verse on the record is written by Williams and
marks the beginning of their working relationship.

1998

N.O.R.E. (a.k.a. Noreaga) releases the single "Superthug,"
which makes it to number thirty-six on the Billboard
Hot 100. The single is produced by the Neptunes.

1999

Williams, along with Chad Hugo and Shay Haley, form their band, N.E.R.D. (a.k.a. No-one Ever Really Dies).

2001

Members of the Neptunes found their music label, Star Trak Entertainment.

2002

In Search Of . . . , N.E.R.D.'s first studio album, is released by Star Trak, Virgin Records, and EMI.

2003

Williams and Chad Hugo release their compilation album, *The Neptunes Present . . . Clones*, with Star Trak and Arista.

Williams is awarded his first Grammy Awards: Album of the Year for *Nellyville* and Best Rap Performance by a Duo or Group for "Pass the Courvoisier, Part II."

2004

N.E.R.D. releases their second album, *Fly or Die*, with
Star Trak and Virgin Records.

Snoop Dogg releases the chart-topping hit single "Drop
It Like It's Hot," which is produced by the Neptunes
and features Williams. The song reached number one
in the United States on the Billboard Hot 100.

At the 46th Annual Grammy Awards ceremony, Williams
wins two awards (and is nominated for five others):
Best Pop Vocal Album for *Justified* and Producer of the
Year (Non-Classical).

2005

Williams and Nigo collaborate on their fashion lines,
Billionaire Boys Club and Ice Cream.

Esquire proclaims Williams the "Best Dressed Man in
the World."

Williams and Nigo, in design collaboration with
Marc Jacobs, release their Millionaire sunglasses to
accompany Louis Vuitton's spring/summer line,
Women's Prêt-à-Porter.

Williams wins two Grammys (and is nominated for
 another) at the 47th Annual Grammy Awards cere-
 mony: Best Urban/Alternative Performance for
 "She Wants to Move"; and Best Rap Song for "Drop
 It Like It's Hot."
A brick-and-mortar retail space for Billionaire Boys Club
 and Ice Cream opens in Harajuku, Japan.

2006

In My Mind, Williams's first solo album, is released by
 Star Trak and Interscope Records and reaches number
 three on the Billboard 200.
At the 48th Annual Grammy Awards ceremony, Williams
 wins two awards (and is nominated for another):
 Record of the Year for "Hollaback Girl" and Producer
 of the Year (Non-Classical).

2007

Williams wins the Grammy for Best Rap Song for his
 work with Ludacris on the single "Money Maker."
In September, a brick-and-mortar retail space for

Billionaire Boys Club and Ice Cream opens in Hong
Kong. In November, another location opens, this time
in New York.

Jay-Z releases his tenth studio album, *American Gangster*,
which is produced by the Neptunes.

2008

Helen Lasichanh gives birth to Rocket, her and
Williams's first child.

N.E.R.D. releases their third studio album, *Seeing Sounds*,
with Star Trak and Interscope Records.

Williams collaborates with Louis Vuitton to design a line
of jewelry and eyewear.

Williams releases his furniture design project, the
Perspective Chair.

Williams opens his solo exhibition, *Pharrell Williams:
Perspectives*, at Perrotin gallery in Paris (October 21,
2008–January 10, 2009).

Williams launches the nonprofit foundation From
One Hand to Another, with the goal to provide
children with "experiences that ignite their passions,
challenge their minds, and prepare them for success."

In collaboration with Louis Vuitton, Williams releases a
 line of luxury jewelry called Blason.

2009
Williams releases his second furniture design project,
 the Tank Chair.
Billboard claims "Drop It Like It's Hot" the most popular
 rap song of the decade.
Williams, along with cocreators Takashi Murakami and
 Jacob & Co., release their sculpture, The Simple Things,
 at Art Basel Miami Beach.

2010
N.E.R.D. releases their fourth studio album, Nothing,
 with Star Trak and Interscope Records.
Interscope and Star Trak release Williams's original
 motion picture soundtrack to Despicable Me.
In collaboration with Moncler, Williams releases a line
 of limited-edition outerwear.

2012

Williams starts his multimedia company I Am Other, to "explore the pursuit of individuality, the defiance of expectations, and the arrival of a new class of visionaries."

Williams's book *Pharrell: Places and Spaces I've Been* is published by Rizzoli.

2013

Williams performs on the two hit singles, "Lose Yourself to Dance" and "Get Lucky," on Daft Punk's fourth studio album, *Random Access Memories*.

Back Lot Music releases Heitor Pereira and Williams's original motion picture soundtrack to *Despicable Me 2*.

Moncler partners with Williams and releases a new line of their Lunettes sunglasses. In conjunction with the release, Moncler reissues Williams's line of outerwear in a new color scheme.

Williams and Helen Lasichanh are married in Miami, Florida, on October 12.

Williams releases his hit single "Happy," which climbs to number one on the Billboard Hot 100.

The twenty-four-hour music video for "Happy" is
 released in November.

2014
Williams and G-Star launch G-Star RAW for the Oceans.
Girl, Williams's second studio album, is released by I Am
 Other and Columbia Records.
Girl, a group exhibition curated by Williams, opens at
 Perrotin gallery in Paris (May 27–June 25, 2014).
Williams collaborates with Uniqlo on their I Am Other
 collection.
The Moynat × Pharrell fall/winter collection is released.
Billionaire Boys Club partners with Takashi Murakami
 and releases a T-shirt to coincide with Murakami's
 film Jellyfish Eyes.
Williams becomes a singing coach on the NBC television
 series The Voice.
At the 56th Annual Grammy Awards ceremony, Williams
 is awarded four Grammys (and is nominated for
 three others): Record of the Year for "Get Lucky,"
 Album of the Year for Random Access Memory, Best
 Pop Duo/Group Performance for "Get Lucky," and
 Producer of the Year (Non-Classical).

2015

Williams partners with Adidas and begins releasing new
 sneaker and clothing designs.

At the 57th Annual Grammy Awards ceremony, Williams
 takes home three awards (and is nominated for three
 others): Best Urban Contemporary Album for *Girl*,
 Best Solo Pop Performance for a live performance of
 "Happy," and Best Music Video, also for "Happy."

2016

Happy, Williams's book for children and adaptation of his
 hit song by the same name, is published by Putnam.

Columbia Records releases the motion picture
 soundtrack to *Hidden Figures*, which is produced by
 Williams and features performances by him as well.

Williams assumes co-ownership of G-Star RAW.

Williams wins a Grammy (Best Rap Song) at the 58th
 Annual Grammy Awards ceremony for work he did
 with Kendrick Lamar on Lamar's hit single "Alright."

In November, a new brick-and-mortar retail space
 for Billionaire Boys Club and Ice Cream opens in
 Manhattan.

2017

Lasichanh gives birth to triplets.

N.E.R.D. releases their fifth studio album, *No One Ever Really Dies*, with I Am Other and Columbia Records.

I Am Other and Columbia Records releases the original motion picture soundtrack to *Despicable Me 3*, which features several tracks by Williams.

Williams, visual artist JR, and the artist group duo OSGEMEOS collaborate on a limited-edition art project called #1983 BOOMBOX.

2018

Williams's third book, *Pharrell: A Fish Doesn't Know It's Wet*, is published by Rizzoli.

2019

Williams's annual music festival, Something in the Water, opens to audiences for the first time.

Williams and visual artist Mr.'s exhibition, *Carte Blanche to Mr. and Pharrell Williams: A Call to Action*, runs at the Guimet National Museum of Asian Arts in Paris (July 11–September 23).

2020

Williams partners with David Grutman and opens
Goodtime Hotel in Miami, Florida.

Williams launches his skincare company, Humanrace.

2022

Williams wins the Producer of the Year (Non-Classical)
Grammy Award at the 61st Annual Grammy Awards
ceremony.

Pharrell Williams was born in Virginia Beach, Virginia, where he formed the hip-hop and production duo the Neptunes with close friend Chad Hugo in the early 1990s. In 1999, he became the lead vocalist in the band N.E.R.D. and in 2006 released his debut solo album *In My Mind*. Throughout his career as a musician and producer, he has collaborated with many top pop and hip-hop artists and has been widely referred to as one of the most influential music producers of the twenty-first century. Williams has received numerous accolades and nominations, including thirteen Grammy awards, and two Academy Award nominations. Williams is also the cofounder of the streetwear brands Billionaire Boys Club and Ice Cream footwear and has collaborated with many major fashion brands, including Chanel, Louis Vuitton, Adidas, Moncler, and Uniqlo. In addition, Williams is the founder of the social media platform I Am Other, the skincare brand Humanrace, and the digital auction house and content platform JOOPITER.

Larry Warsh has been active in the art world for more than thirty years as a publisher and artist-collaborator. An early collector of Keith Haring and Jean-Michel Basquiat, Warsh was a lead organizer for the exhibition *Basquiat: The Unknown Notebooks*, which debuted at the Brooklyn Museum, New York, in 2015, and later traveled to several American museums. He has loaned artworks by Haring and Basquiat from his collection to numerous exhibitions worldwide, and he served as a curatorial consultant on *Keith Haring | Jean-Michel Basquiat: Crossing Lines* for the National Gallery of Victoria. The founder of *Museums Magazine*, Warsh has been involved in many publishing projects and is the editor of several other titles published by Princeton University Press, including *Basquiat-isms* (2019), *Haring-isms* (2020), *Futura-isms* (2021), *Abloh-isms* (2021), *Arsham-isms* (2021), *Warhol-isms* (2022), *Hirst-isms* (2022), *Jean-Michel Basquiat: The Notebooks* (2017), *Keith Haring: 31 Subway Drawings*, and two books by Ai Weiwei, *Humanity* (2018) and *Weiwei-isms* (2012). Warsh has served on the board of the Getty Museum Photographs Council, and was a founding member of the Basquiat Authentication Committee until its dissolution in 2012.

ACKNOWLEDGMENTS

First, my thanks go to Pharrell Williams, whose words and thoughts constitute the pages of this book. It is a profound honor to be aligned with such a powerful creative force.

My heartfelt thanks to Loïc Villepontoux and his entire team for their unmatched support and presence throughout this project. Special thanks goes to Kellen Roland, Jasmine Mullers, Dre Rojas, Malaika Bigirumwami, Phi Hollinger, Kelly Vallon, and Yarizza Rodriguez.

My sincere appreciation to the entire team at Princeton University Press, especially Michelle Komie, Christie Henry, Terri O'Prey, Cathy Slovensky, Colleen Suljic, Laurie Schlesinger, Cathy Felgar, Kenneth Guay, Jodi Price, Kathryn Stevens, Annie Miller, Whitney Rauenhorst, and Mark Bellis. We remain extremely grateful to PUP for their continued professionalism, encouragement, and passion for our projects together throughout the years.

I would also like to acknowledge Lenny McGurr, Daniel Arsham, Brian Donnelly, Karl Cyprien, Denis Dekovic, Mike

Dean, Louise Donegan, Sickamore, Ferg, Nigo, Keith Miller, Noah Wunsch, and Carlos "oggizery_los" Desrosiers.

Very special thanks to Editorial Director Fiona Graham for her invaluable research and organization of this publication.

My sincere thanks to Taliesin Thomas for her amazing assistance on this and many other projects, and to Steven Rodríguez, and John Pelosi, for their continued support.

My thanks as well to Matthew Christensen, Susan Delson, and Rickey Kim for their editorial assistance.

Finally, I give all my bottomless gratitude to my amazing wife, Abbey, and to my wonderful children, Justin, Ethan, Ellie, and Jonah for their love and encouragement.

As always, I give endless love and thanks to my mother, Judith.

LARRY WARSH

ILLUSTRATIONS

Frontispiece: © Erik Ian

Page 132: © Dan Hall

ISMS
Larry Warsh, Series Editor

The ISMS series distills the voices of an exciting range of visual artists and designers into captivating, beautifully made books of quotations for a new generation of readers. In turn passionate, inspiring, humorous, witty, and challenging, these collections offer powerful statements on topics ranging from contemporary culture, politics, and race, to creativity, humanity, and the role of art in the world. Books in this series are edited by Larry Warsh and published by Princeton University Press in association with No More Rulers.

Pharrell-isms, Pharrell Williams
Lennon-isms, John Lennon
Ono-isms, Yoko Ono
Hirst-isms, Damien Hirst
Warhol-isms, Andy Warhol
Arsham-isms, Daniel Arsham

Abloh-isms, Virgil Abloh
Futura-isms, Futura
Haring-isms, Keith Haring
Basquiat-isms, Jean-Michel Basquiat